How to Draw

People in Action

In Simple Steps

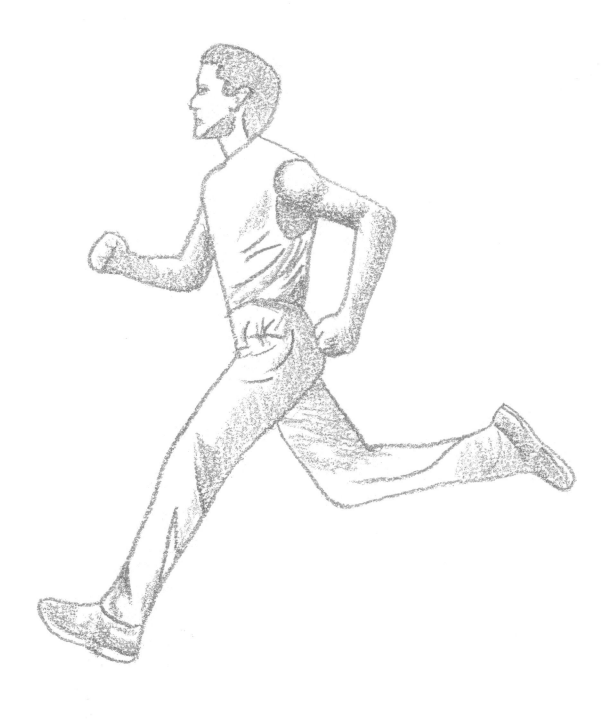

First published in Great Britain 2017

Search Press Limited
Wellwood, North Farm Road,
Tunbridge Wells, Kent TN2 3DR

Text copyright © Susie Hodge 2017

Design and illustrations copyright © Search Press Ltd. 2017

ISBN: 978-1-78221-340-6

Printed in Malaysia

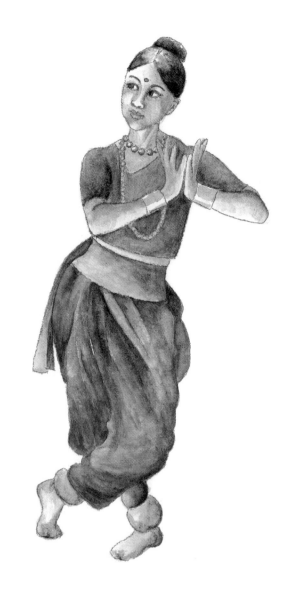

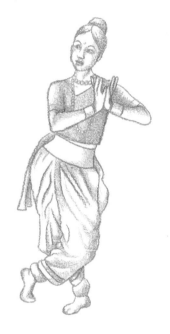

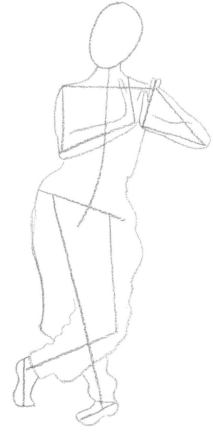

Illustrations

How to Draw
People in Action
In Simple Steps
Susie Hodge

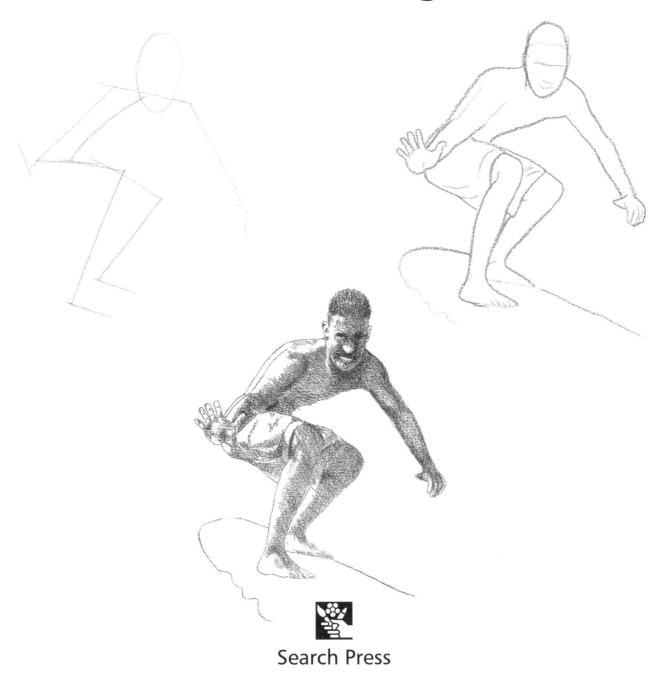

Search Press

Introduction

Welcome to a book full of moving people! Running, dancing, skipping, jumping, playing sport or walking, they are all shown in simple step-by-step drawings. Some are moving quickly, some slowly, some are twisting or bending, but they are all created in the same way; with a straightforward step-by-step method. If you follow the stages, you will soon master these easy techniques.

The aim of this book is to demystify the drawing process and to encourage aspiring artists to view each figure as a collection of simple shapes and lines – which is what it is. When an image is broken down like this, the process becomes easier than it might seem at first. Before you begin, try not to think about the finished image but draw each stage carefully, concentrating on proportion, ratios and angles – how far does that spine tilt, how long is the arm from shoulder to elbow, what size is the head in proportion to the calf?

In this book, two colours are used in the stages to make the sequences easier for you to follow. You can use a pencil – make it fairly soft, such as a B or 2B – as the coloured pencil method here is just so you can see each step clearly. In the first stage, the drawings are in blue, marking the basic elements of the body. In the next stage, those first lines become orange and all new lines are in blue – this time the general outline of the person. In the next step, contours of clothing and some details of folds are marked. Finally, in blue, facial features, hair, clothing details and tones, or shading, are added. With your pencil, draw the steps lightly and erase any previous guidelines after each one is finished. Take your time and make sure you have drawn the correct proportions before you move on to the next step.

After the coloured sequence, each figure is also drawn in pencil to show you what yours might look like. Use a light touch, don't draw every shoelace or every eyelash, but include only general, overall indications, such as a few creases as a person turns or bends, or some stray strands of hair. Often the small, almost unfinished areas seem to breathe life into a drawing.

The final image on each page is to show you another option of what you can do, this time with watercolour. Again, less is often more, particularly on moving figures. Use whatever materials you like, but if you are using watercolour, keep your water clean and your brushes damp, not too wet.

Each of the sequences in this book presents a different challenge to help make the drawing process less daunting. So I hope you try drawing all the figures and then try drawing some of your own. Don't become upset over mistakes, as these happen to everyone. Either erase them, work through them, or start again – but don't give up! If you follow the visual instructions in this book, you will soon feel more confident about your drawing skills and develop your own natural style.

I hope that you will be delighted with your achievements.

Happy Drawing!

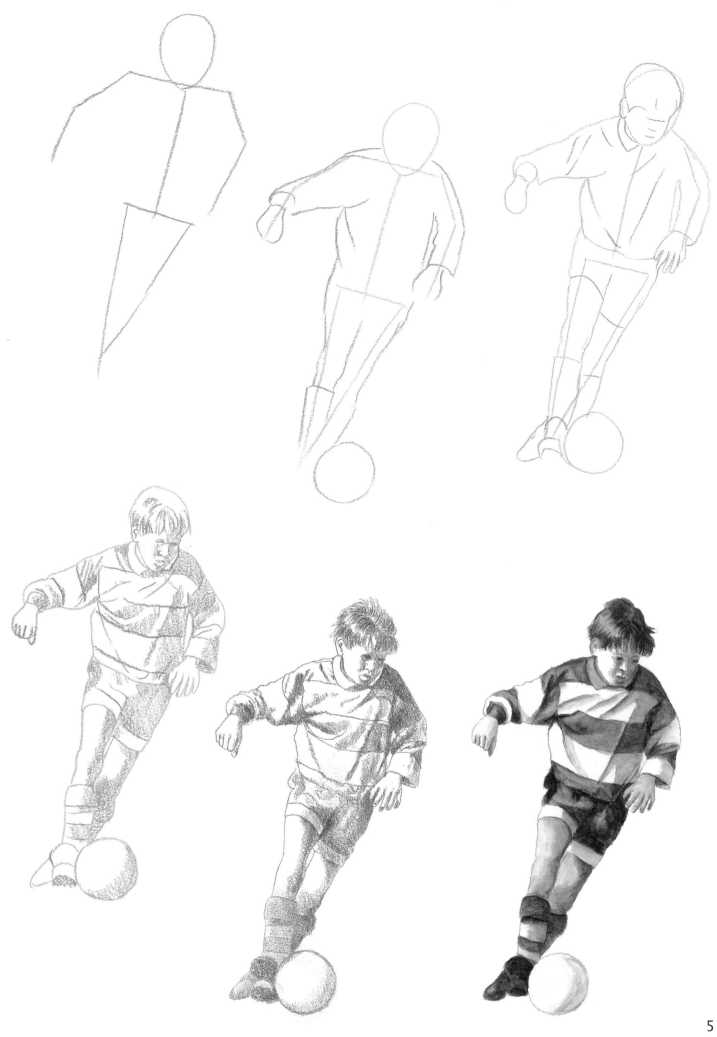

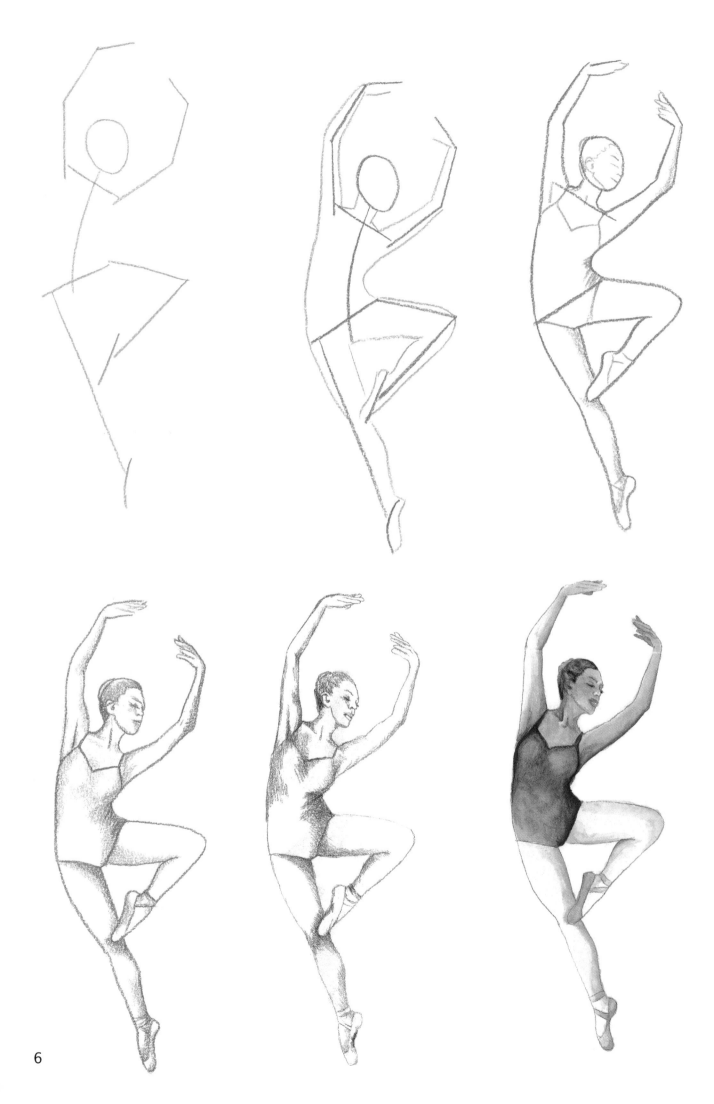

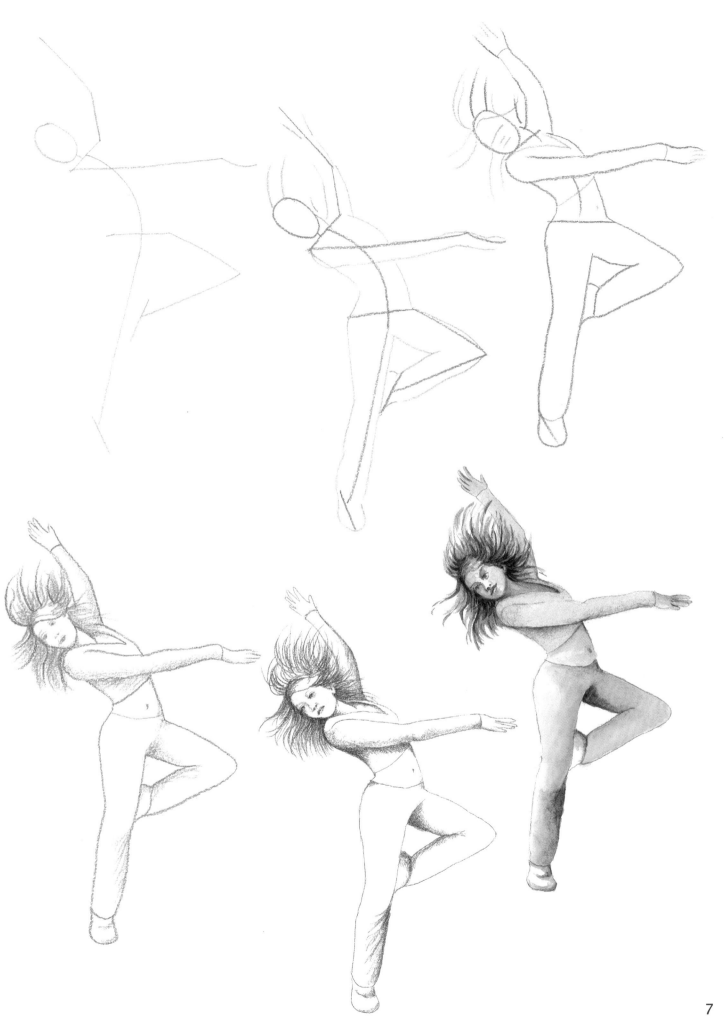

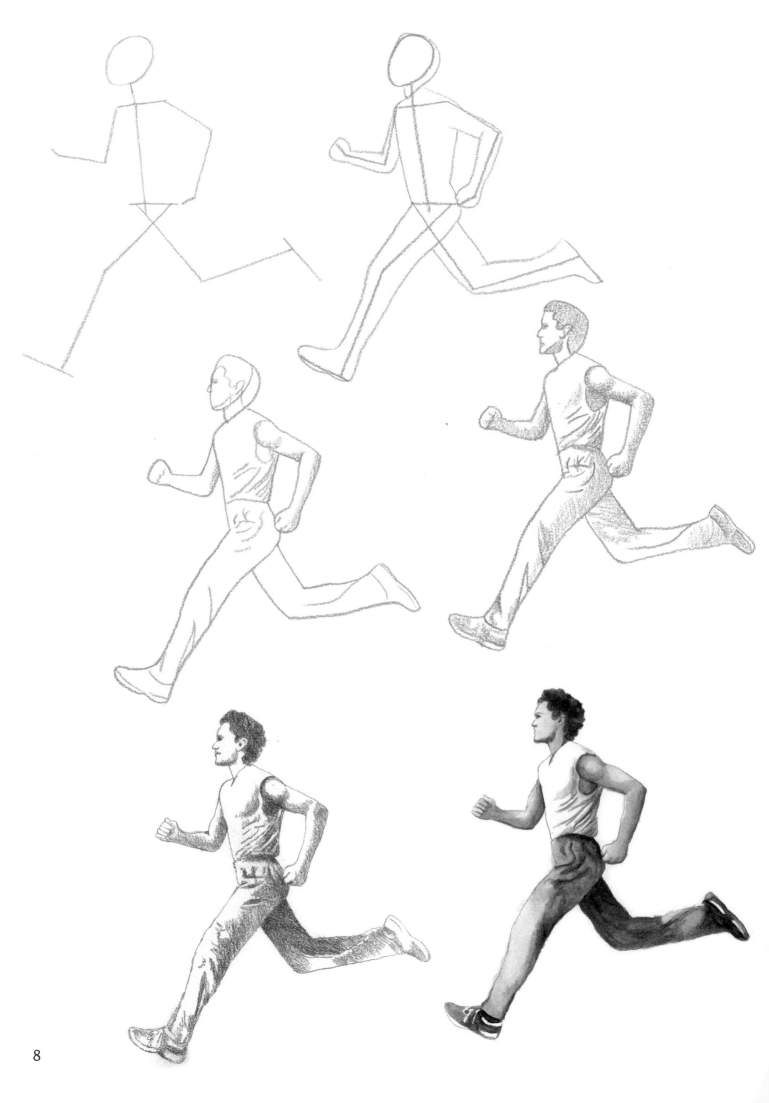

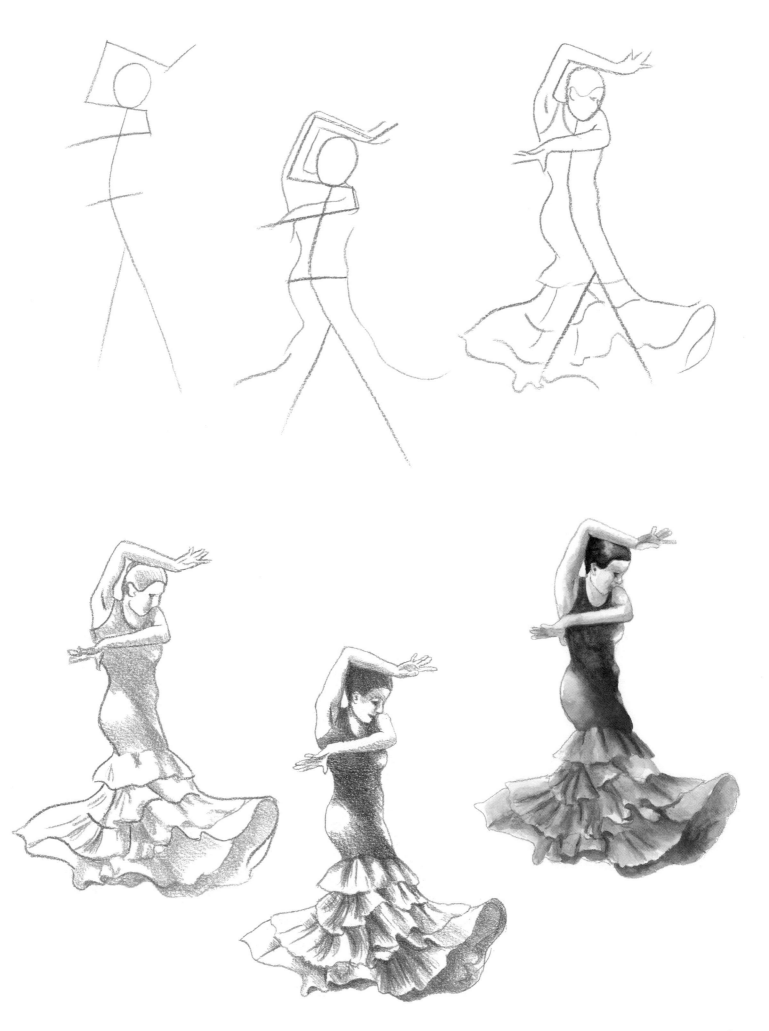

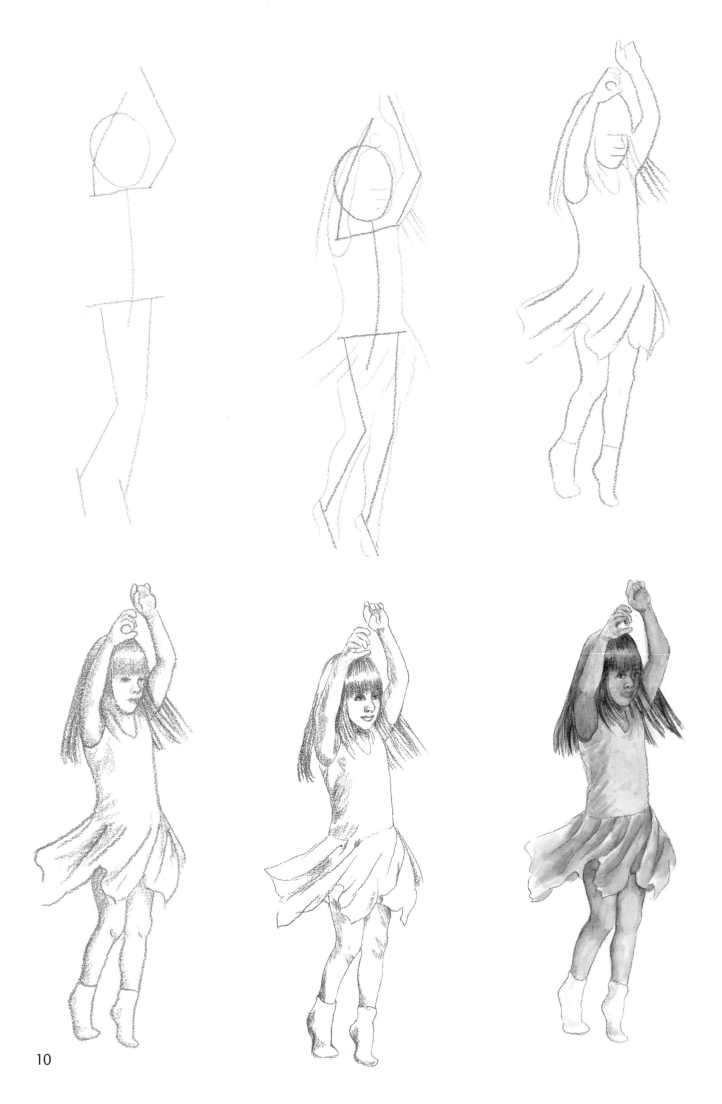

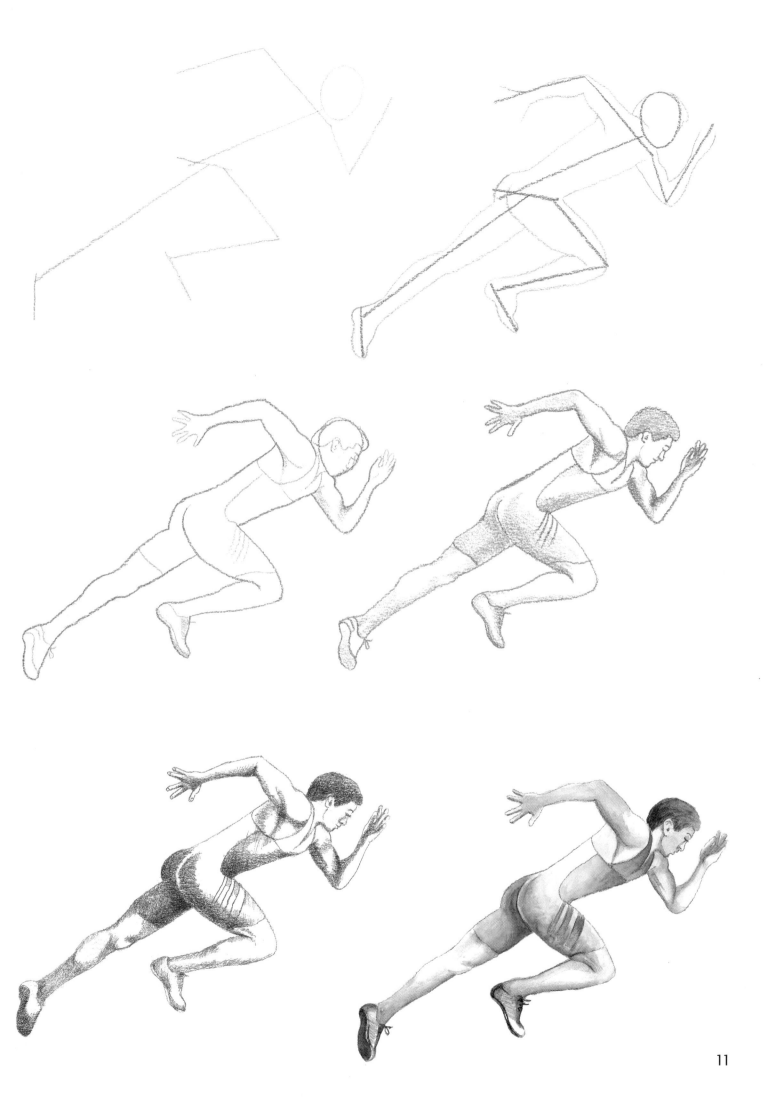

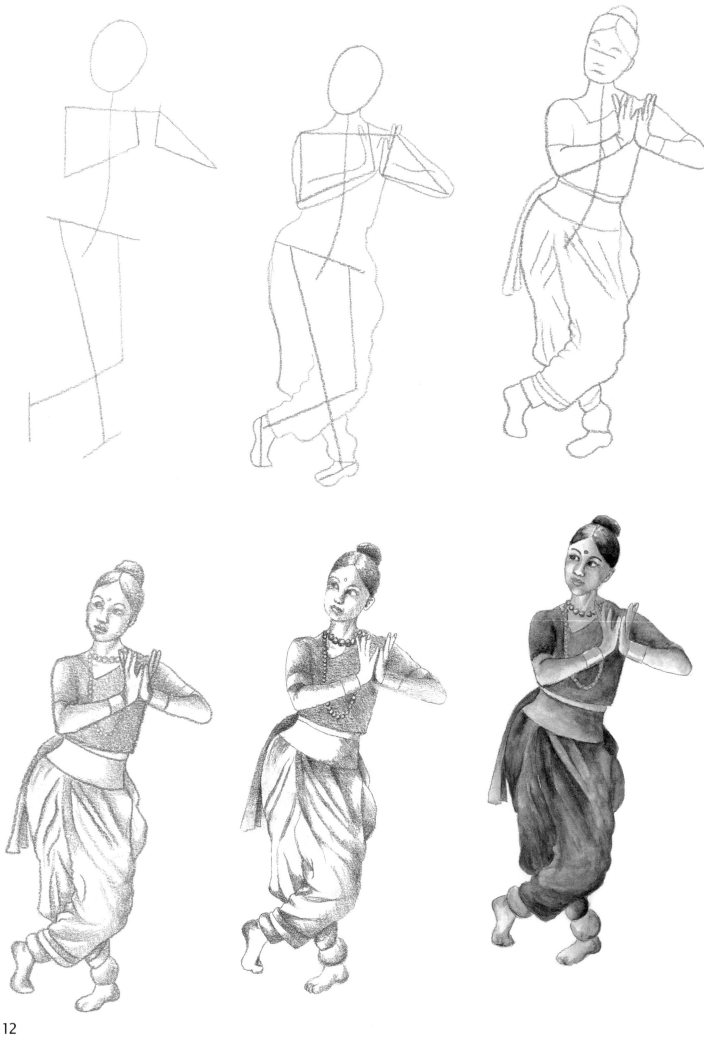

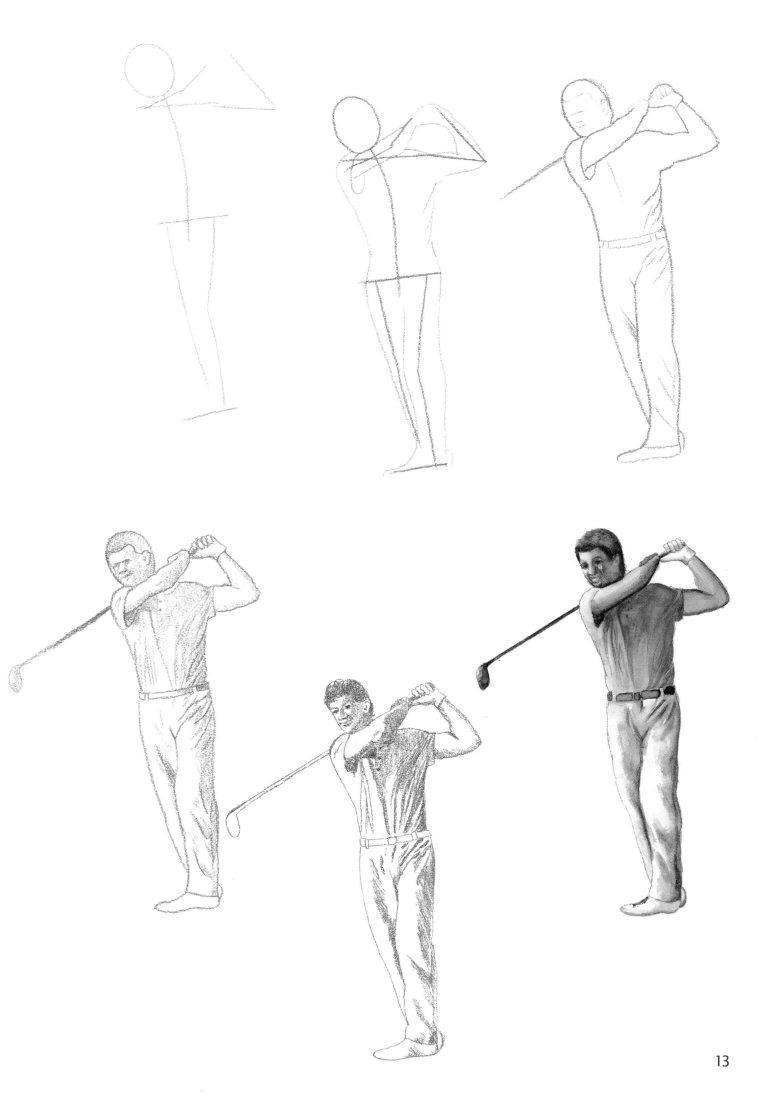

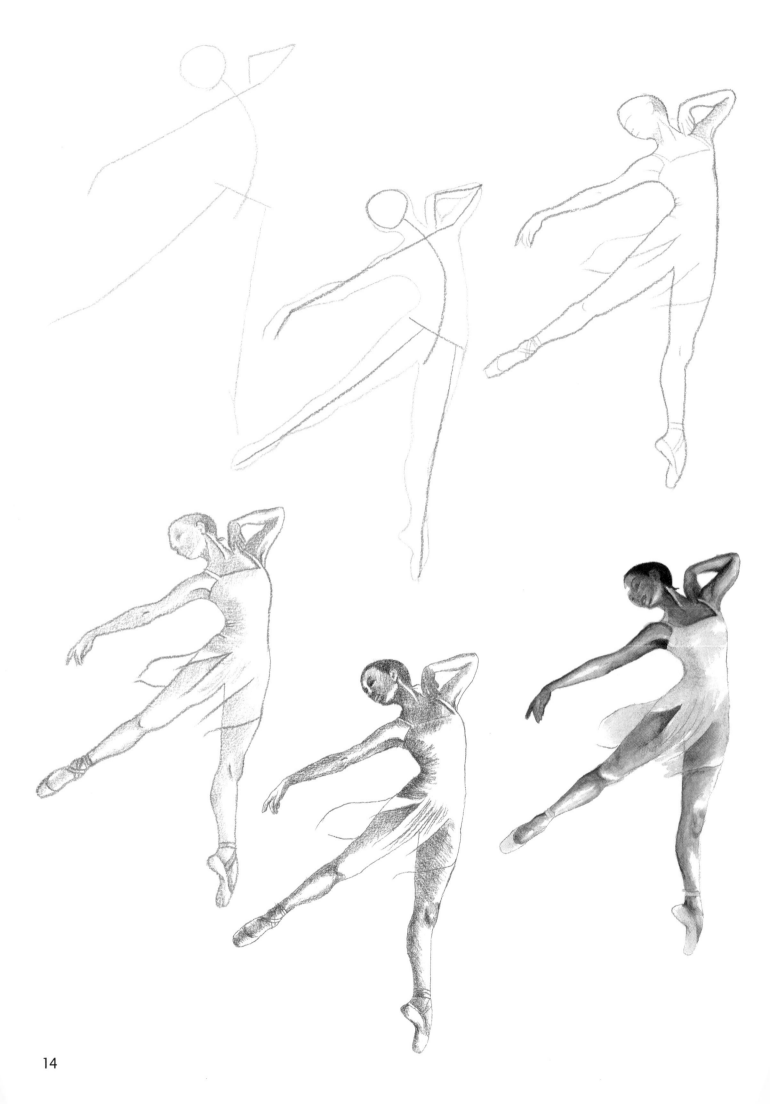

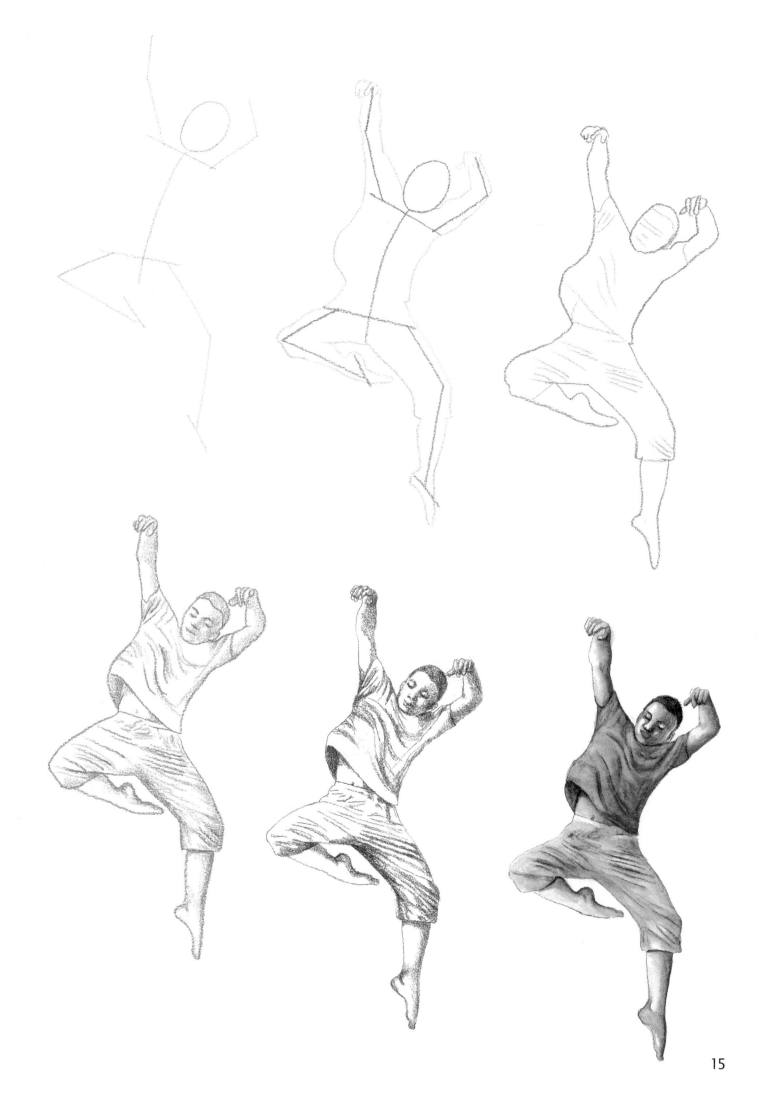

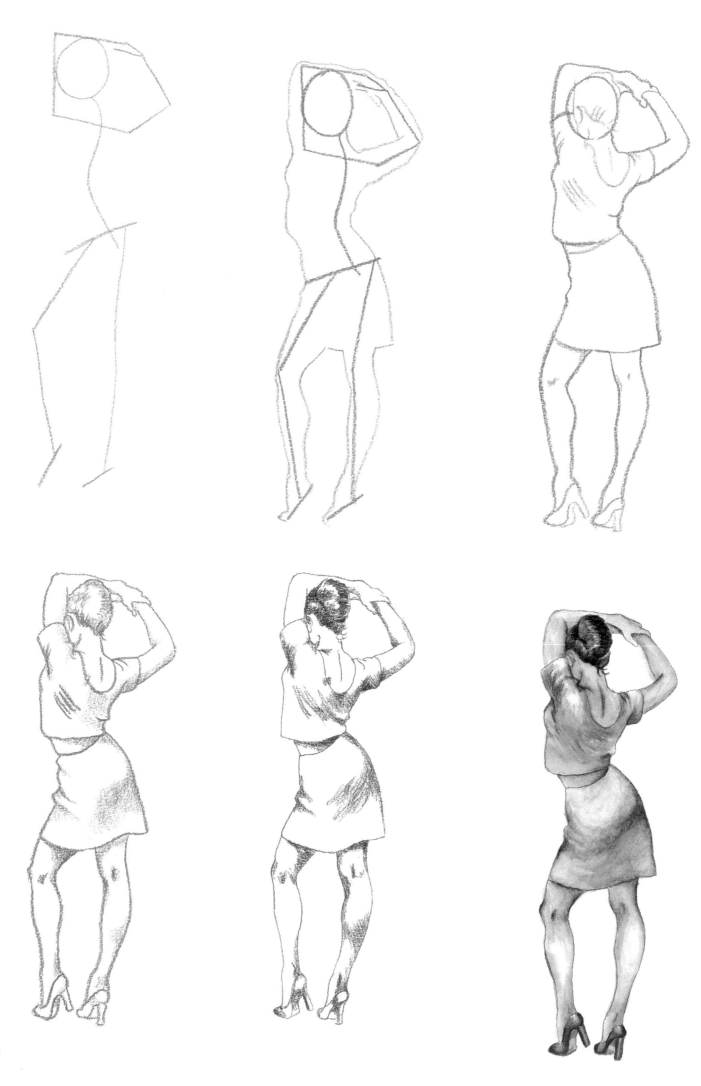

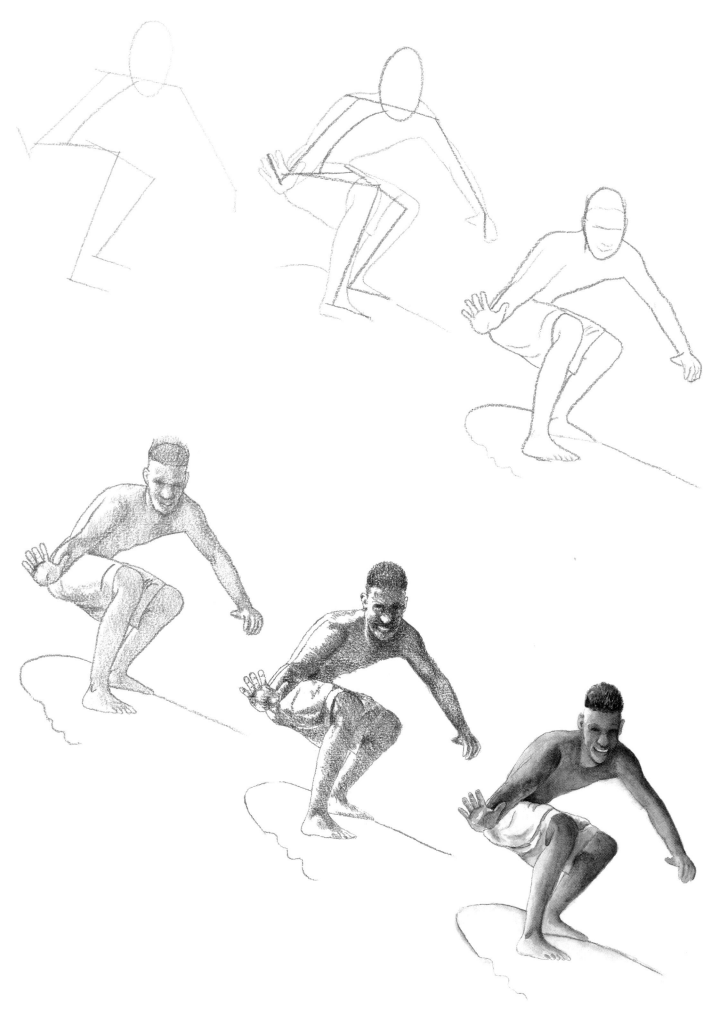

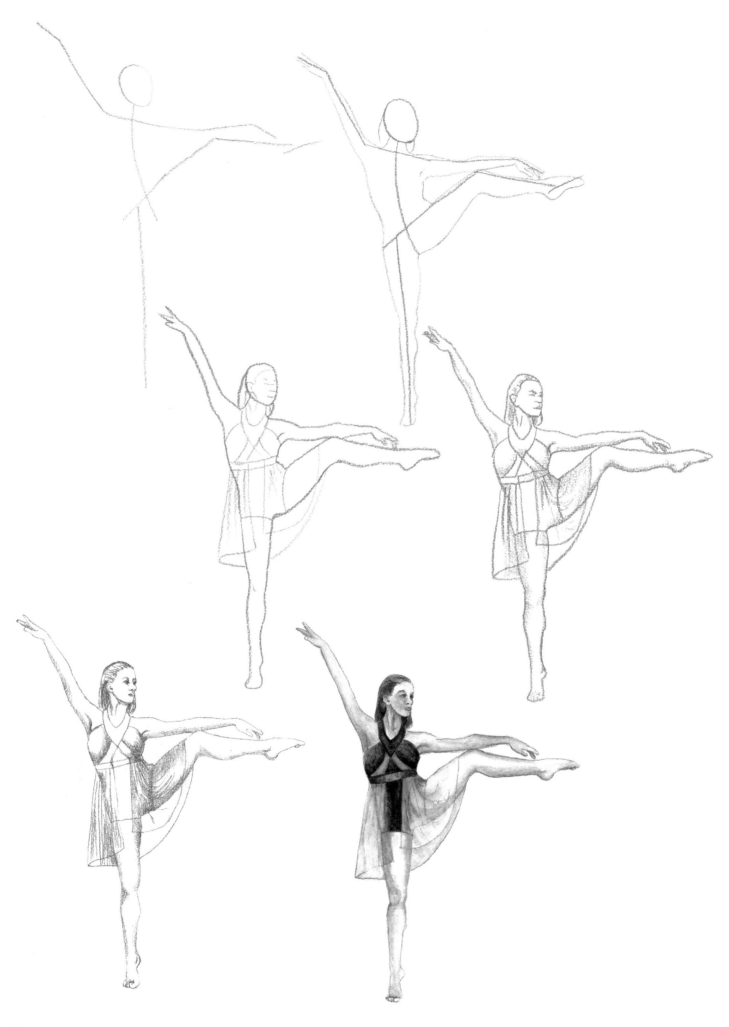

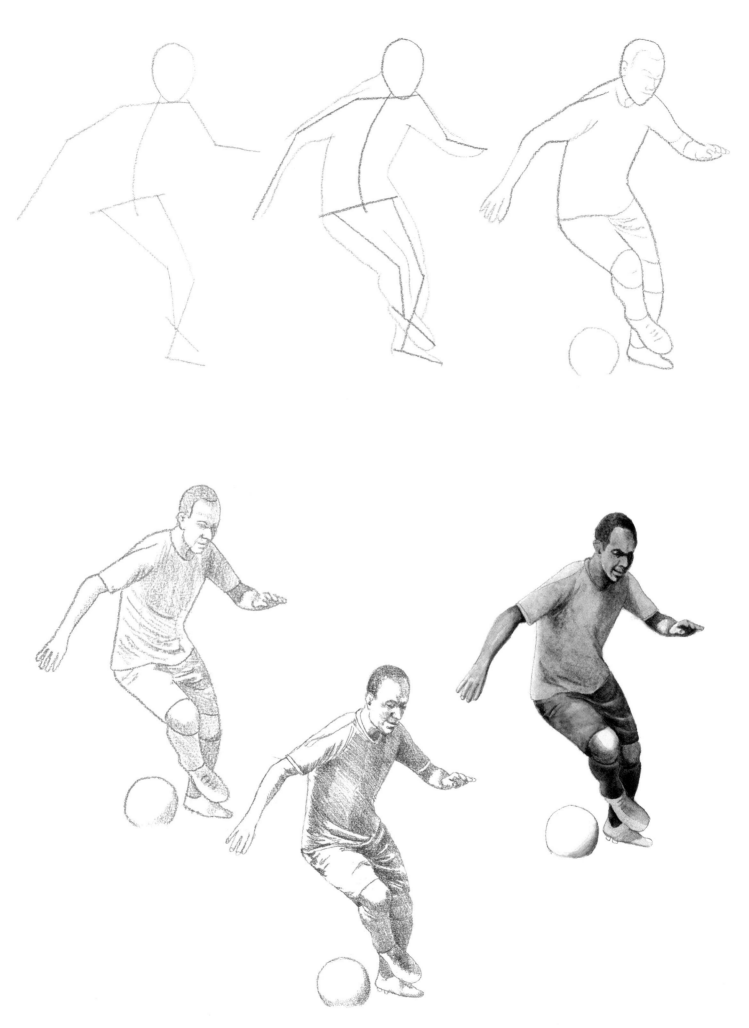

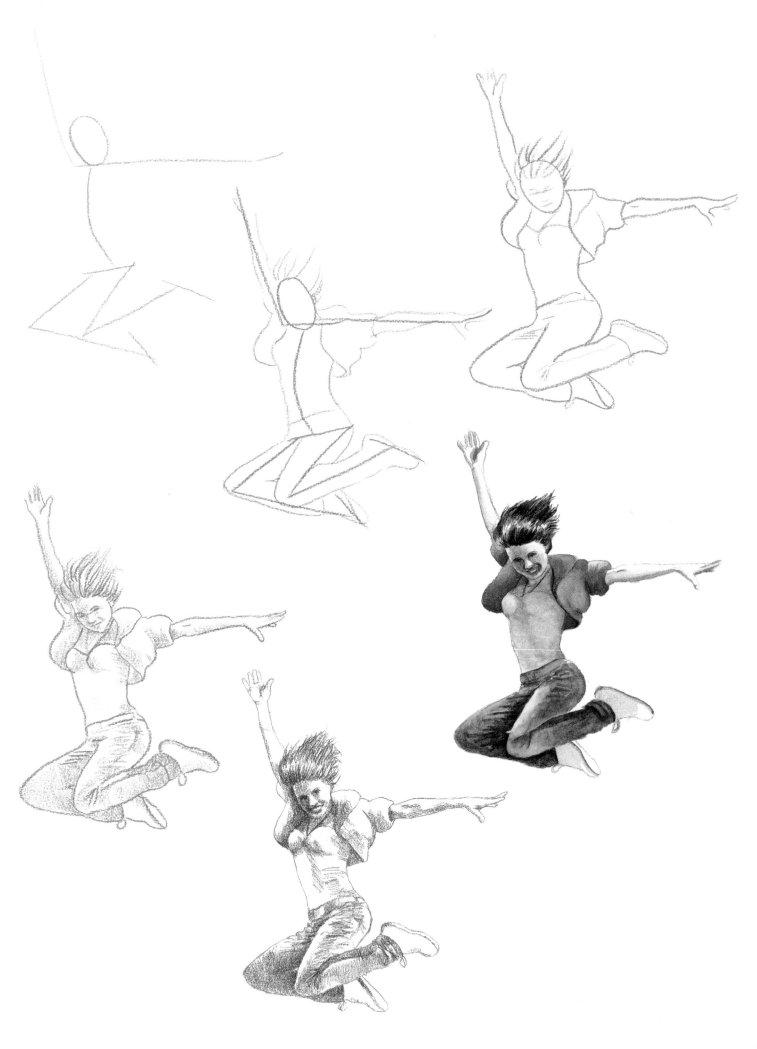

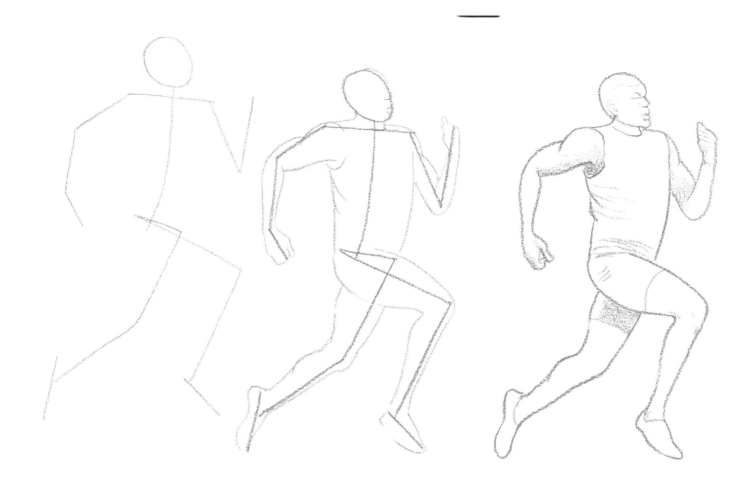

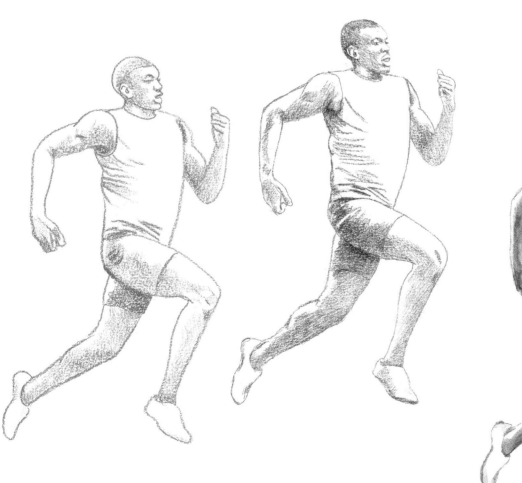

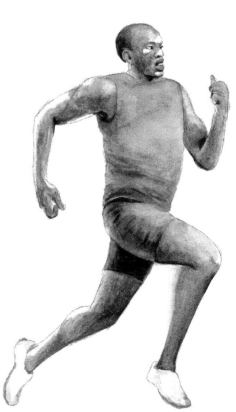

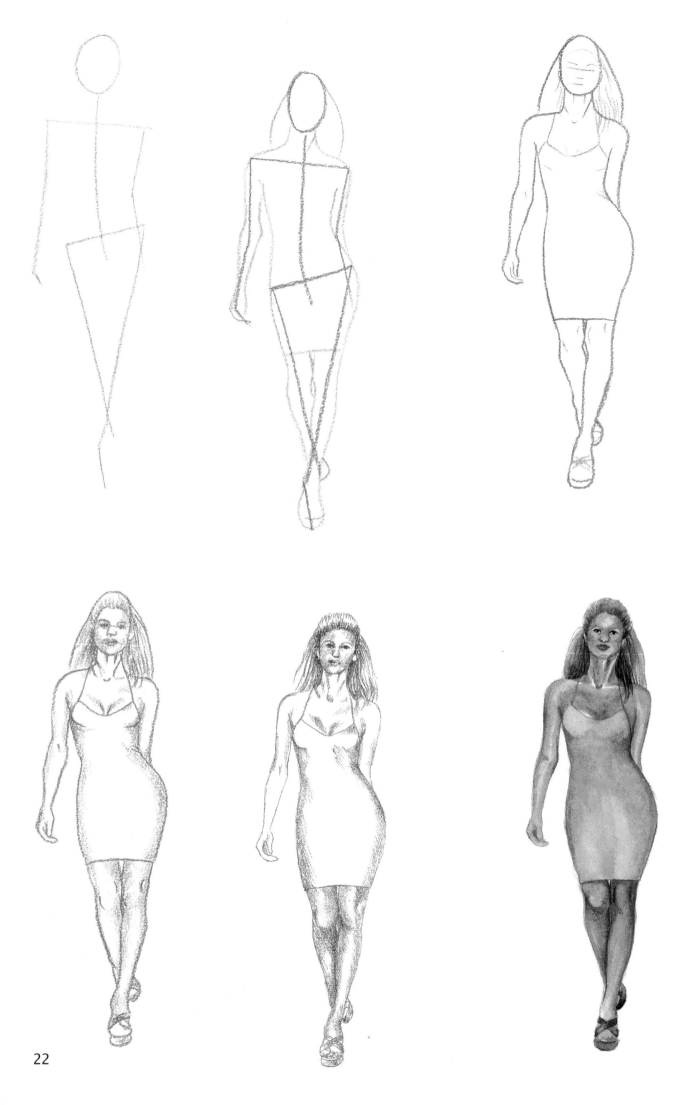

22

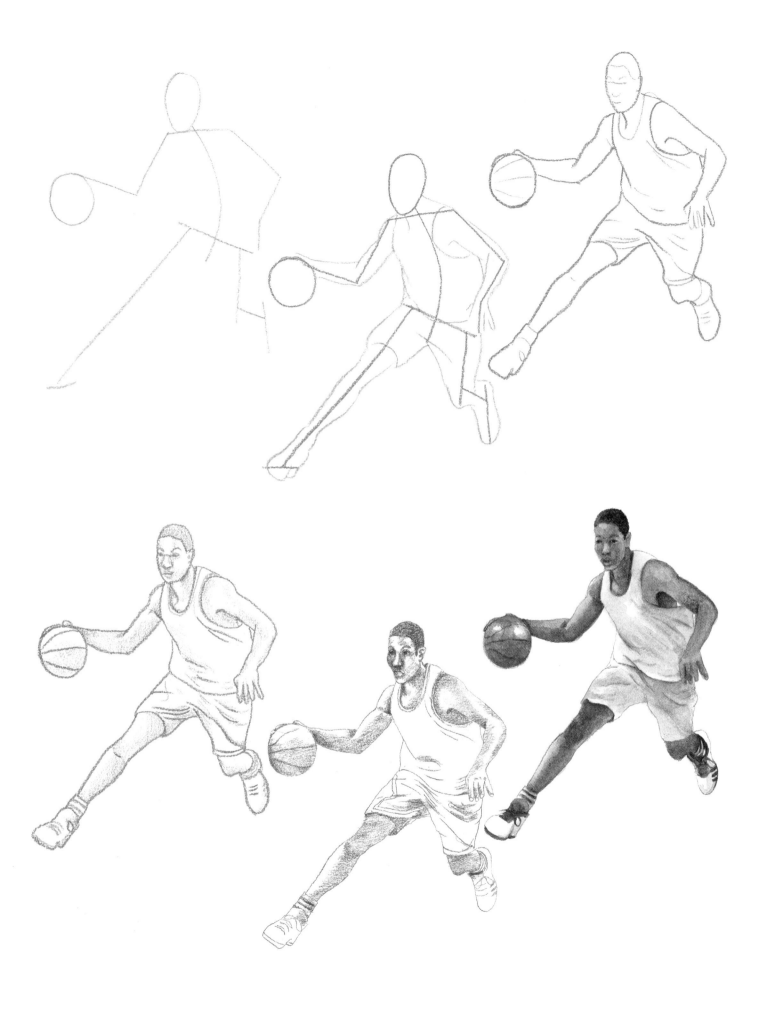

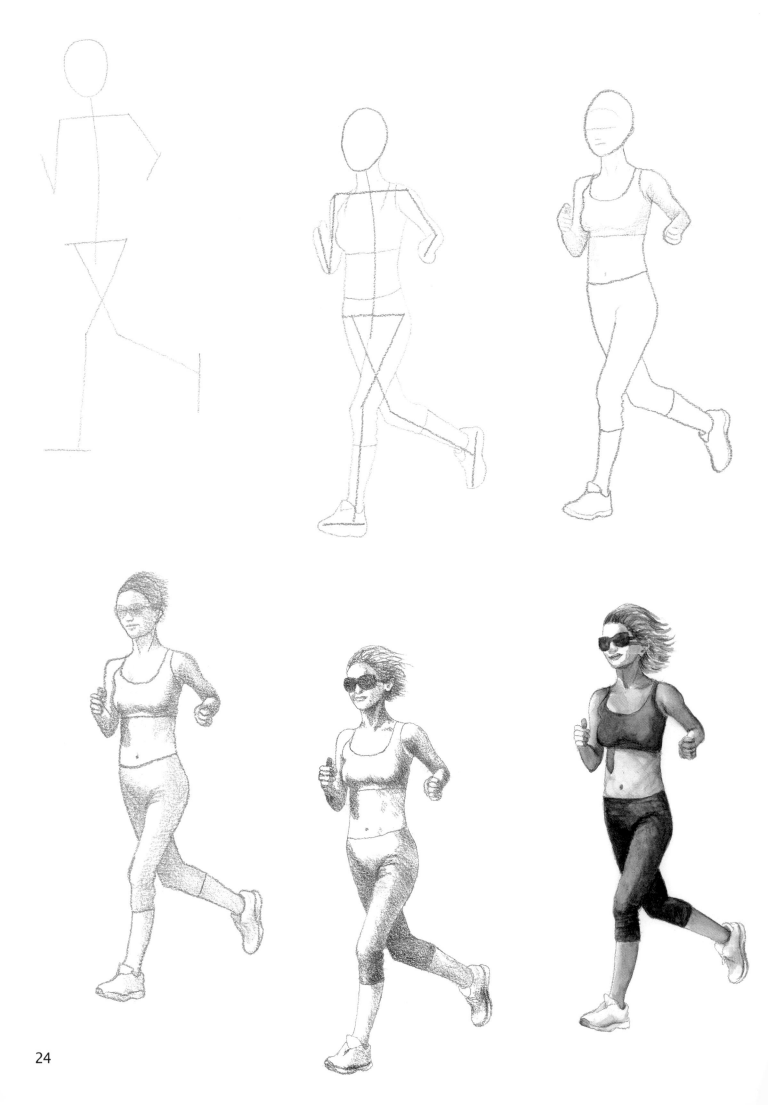

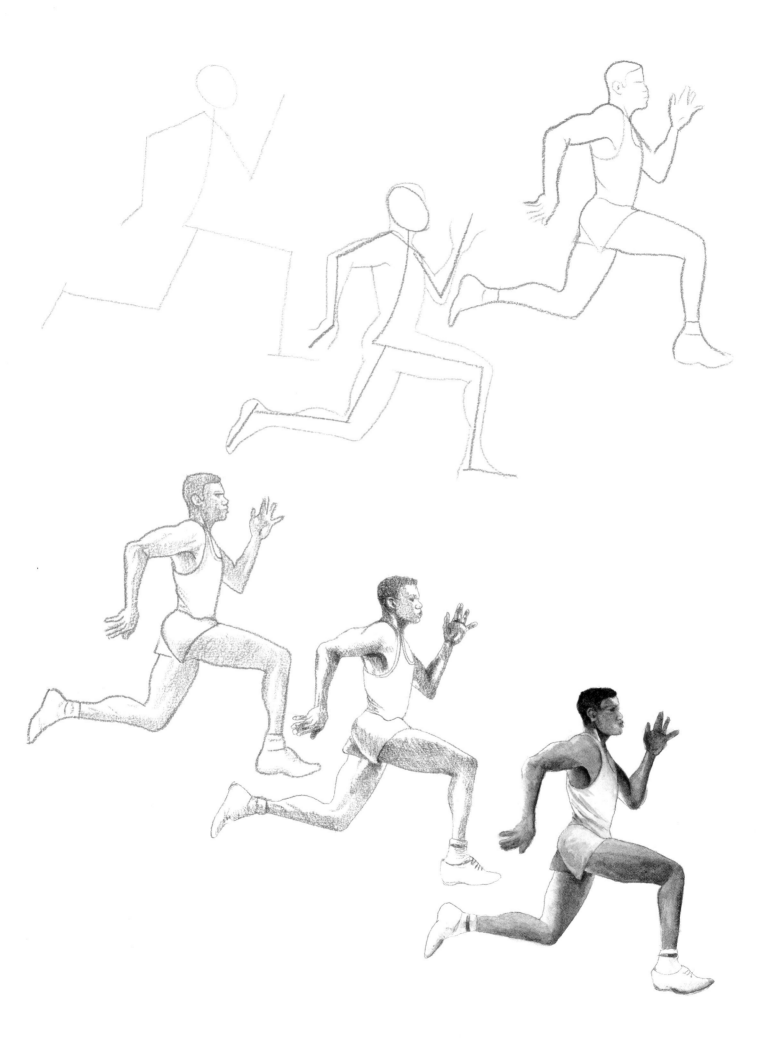

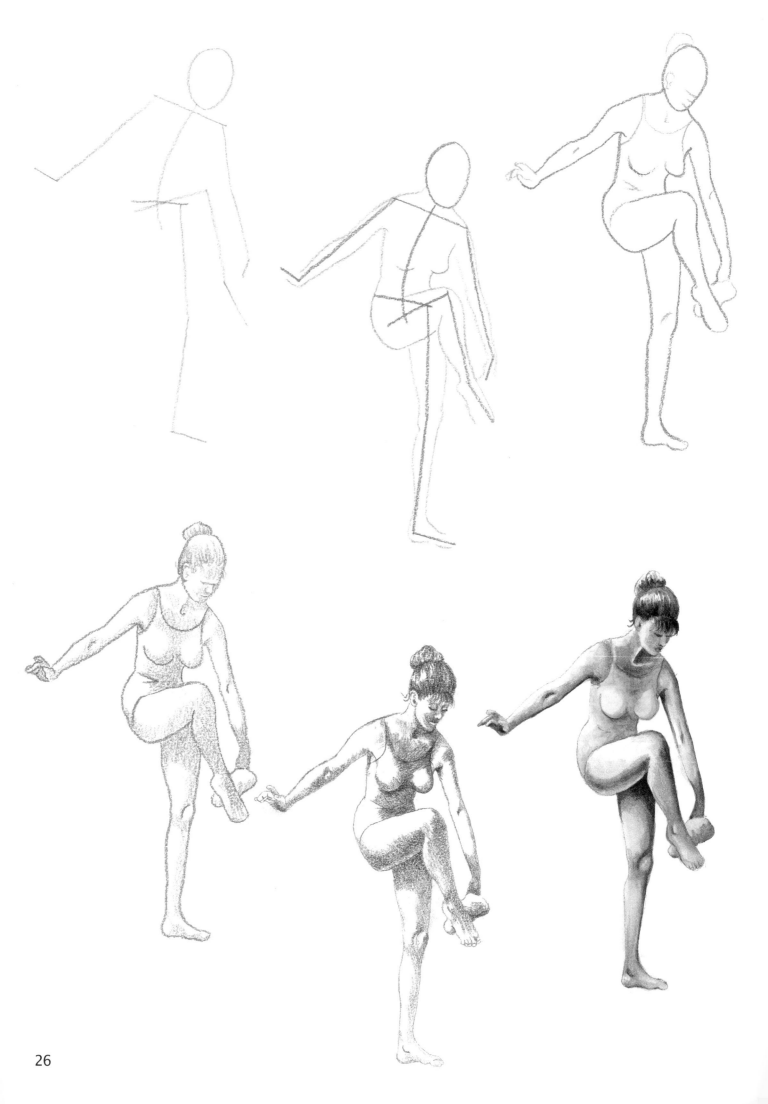

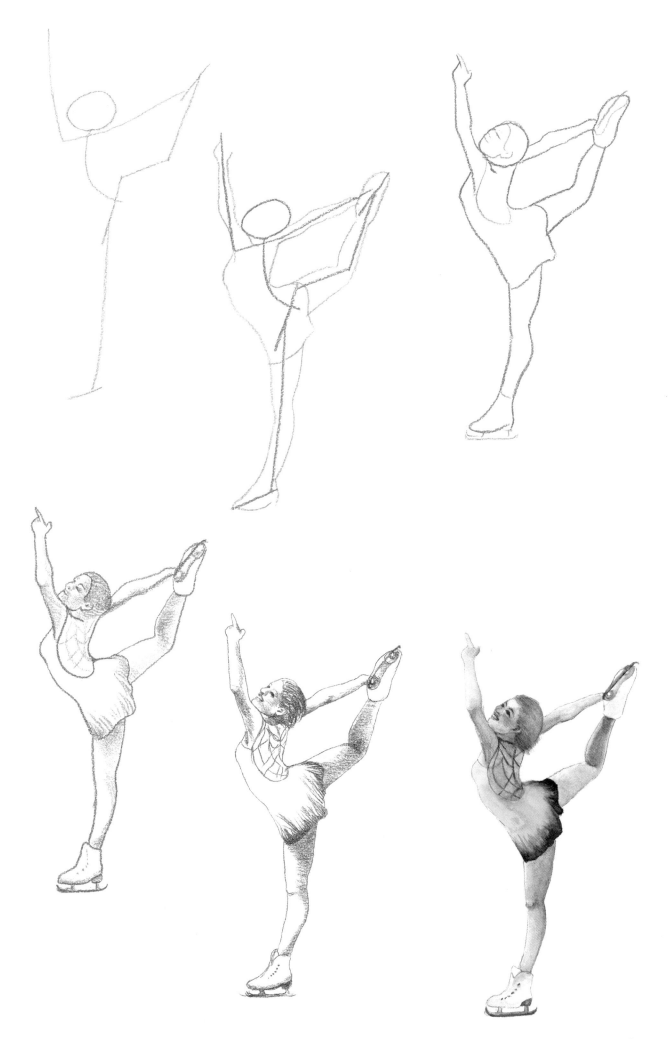

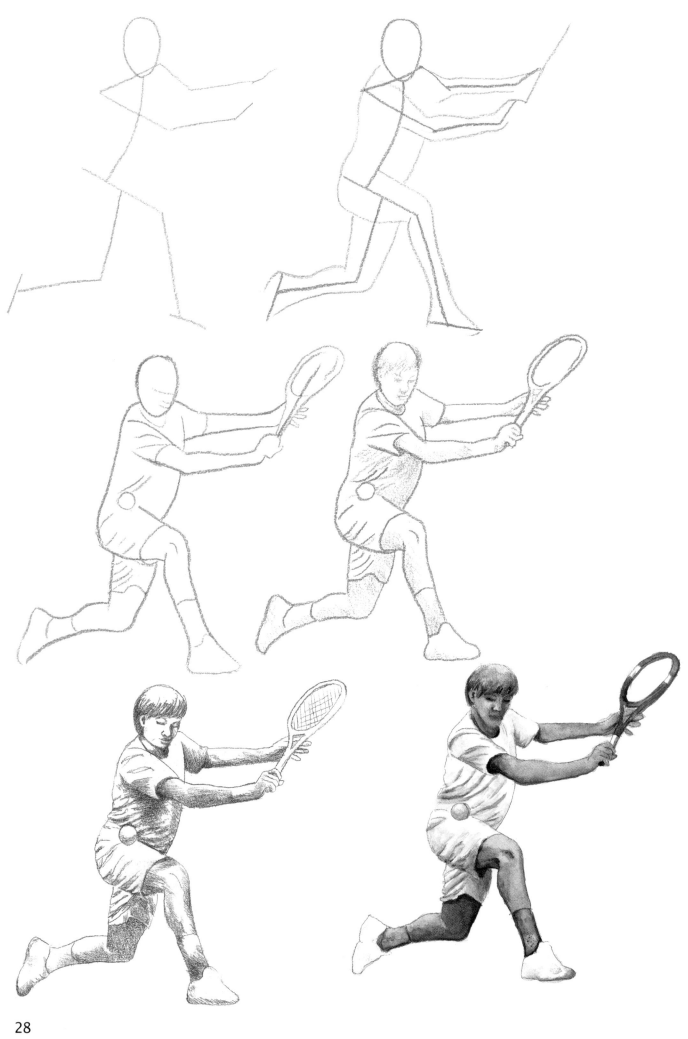

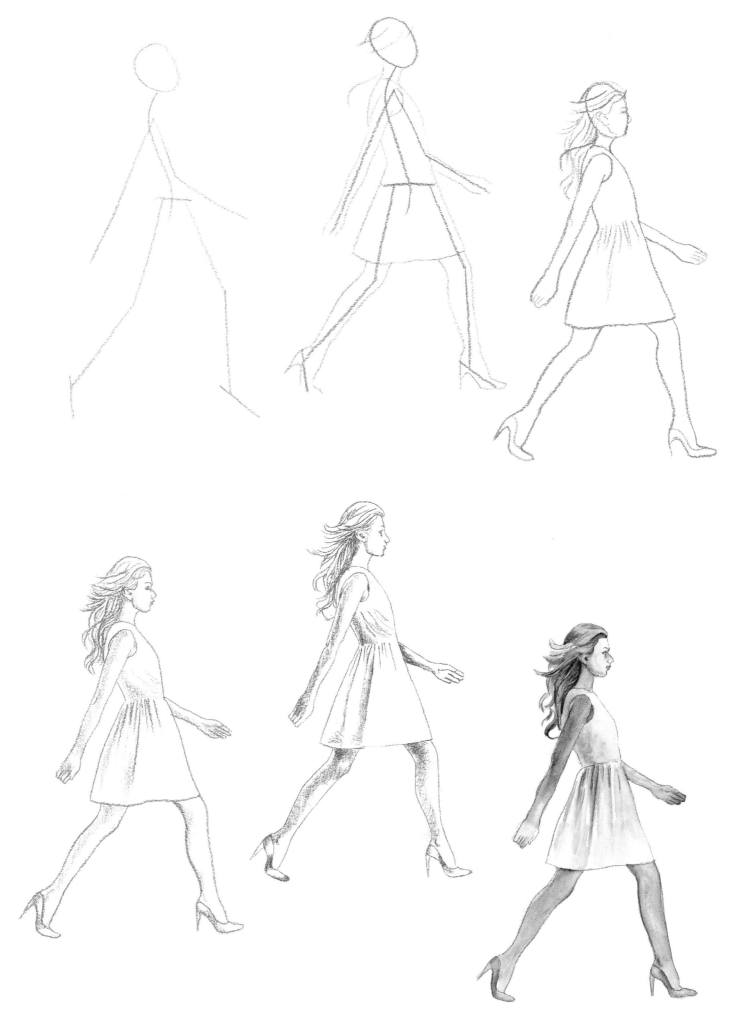

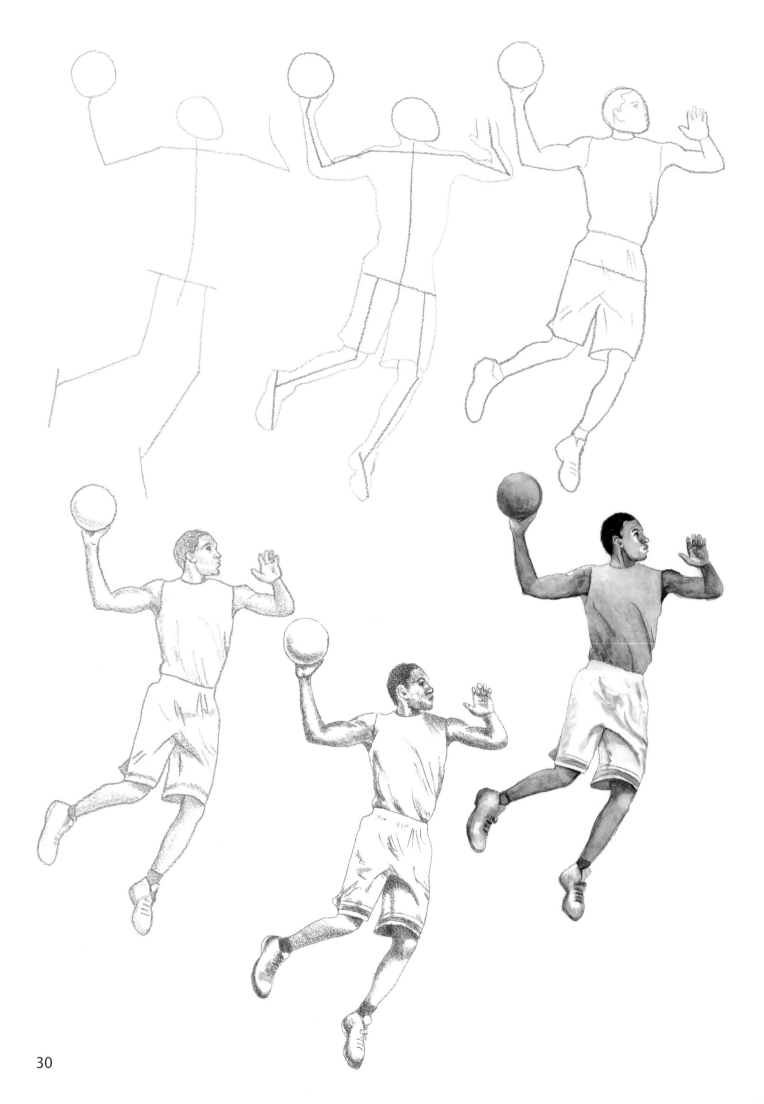

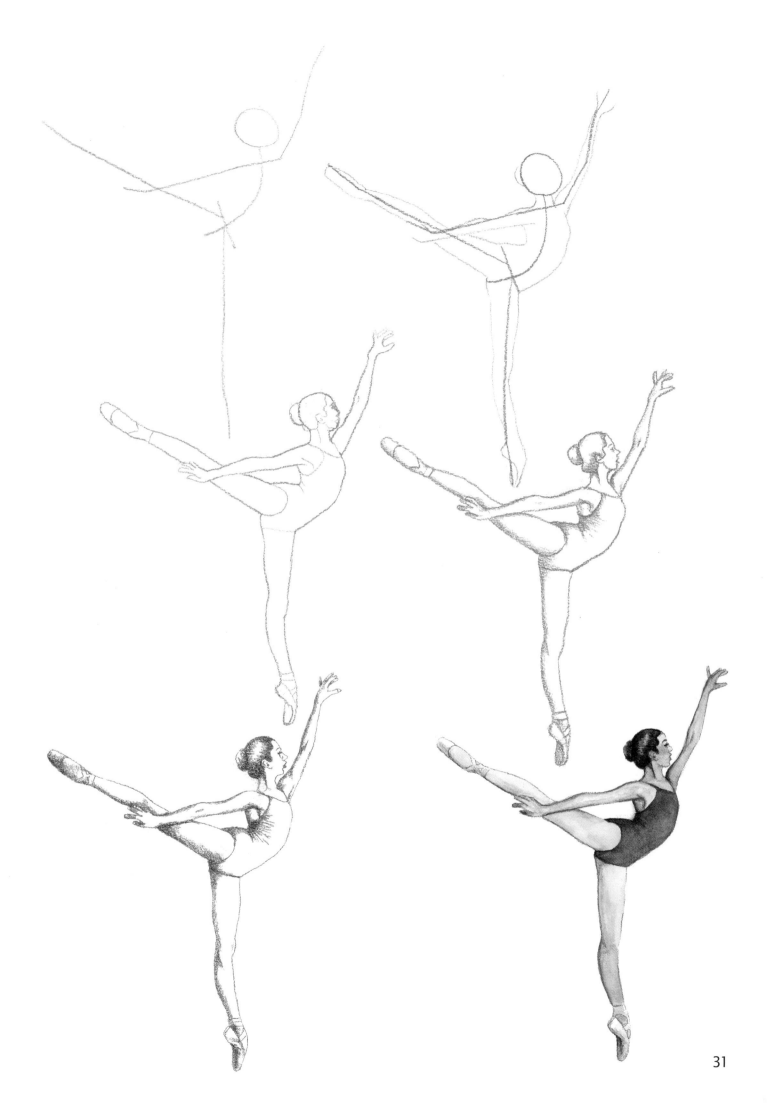

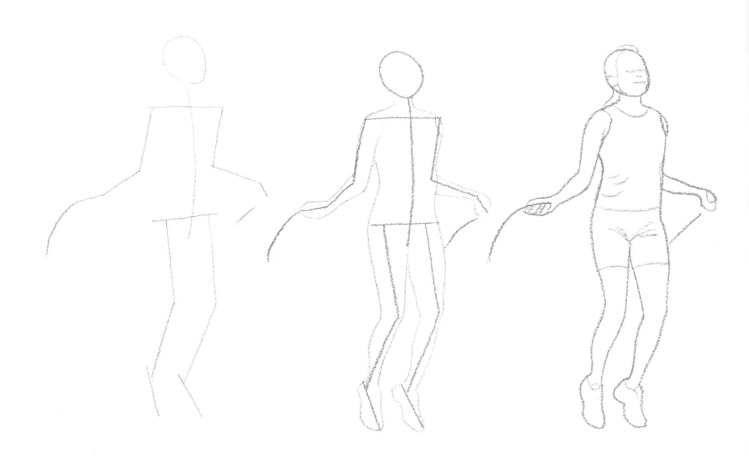